Brian Webb & Peyton Skipwith

Paul Nash

DESIGN

John Nash

Antique Collectors' Club

Design: Paul and John Nash © 2006 Brian Webb and Peyton Skipwith
John Nash © Estate of John Nash 2006 Reproduced with kind permission
Paul Nash © 2006 Tate, London 2006
Foreword © Ronald Blythe 2006

World copyright reserved
First published 2006
Reprinted 2010

ISBN 978-1-85149-519-1

British Library Cataloguing-in-Publication Data.
A catalogue record for this book is available from the British Library.

Antique Collectors' Club

Sandy Lane, Old Martlesham,
Woodbridge, Suffolk IP12 4SD, UK
Tel: 01394 389950 Fax: 01394 389999
Email:info@antique-acc.com
or
6 West 18th Street, Suite 4B,
New York, NY 10011, USA
Tel: 212 645 1111
Fax: 212 989 3205
Email: sales@antiquecc.com

www.antiquecollectorsclub.com

Acknowledgements
With thanks to Sir Peter Blake, Collinge & Clarke, Susan Wilson and
Heather Forrester, Griselda Lewis, Patrick Rylands and Peter Sampson.

Picture credits
©V&A, pp.46, 61. © London's Transport Museum, pp.47, 64/65.
© RIBA, p.53 (top). © Shell Archive, p.63. © Juliet Henney, p.60
(bottom, private collection)

The endpapers are reproduced from John Nash's Bucks Shell
Guide, 1937.
The engraving's on the title page are from Welchman's Hose (PN)
and Directions to Servants (JN)

Published by Antique Collectors' Club, Woodbridge, England
Design by Webb & Webb Design Limited, London
Printed and bound in China

Foreword

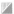

I was a friend of John and Christine Nash, and of their little circle from my early
twenties on. Paul had died just five years earlier. Their combined illustrated books,
now in the Tate Library, were at my bedside and much pored over. I now and then
felt that I knew the brothers better through this work than by their paintings.
Their wit and social style, also their two distinctive kinds of vulnerability were
so evident in these pages. John had begun his comic drawing in his teens, set on
this particular path by all the Edward Lears he had seen in his aunt's house – she
had been engaged to Lear – and he had begun his wonderful plant illustrations
under the influence of Clarence Elliott, the great botanist who had accompanied
Kingdon Ward on his epic plant-hunting journeys. Paul's illustrative progress
was imaginative and visionary. Asked to illustrate Sir Thomas Browne's Urne
Buriall and The Garden of Cyrus, he told John that it was the eureka
moment in his life, for here were the answers to life and death for which he had
been searching. Marble versions of the broken architrave and wise owl from these
essays stand on Paul's grave in Langley churchyard.

John Nash, like John Constable, discovered everything he needed for life and art
wherever he happened to be in the countryside. He liked the utilitarian marks
which men make in it, ditches and ponds and quarries, abandoned machinery and
also wild flowers and trees. This practical understanding of landscape, flora and
climate blows through many of his illustrations. In Gilbert White's Natural
History of Selborne they reveal a perfect match of text and picture.

Their work as designers could be said to have been a crucial part of Paul and
John Nash's livelihood. But it was never thought of by them as inferior to their
painting. When they both wrote and illustrated a book, as they did for John
Betjeman's Shell Guides, it was a delight. Their hearts were in it. This
excellent bringing together of Paul and John as design artists is a treasure.

Ronald Blythe

Ronald Blythe, June 2006

Paul Nash, book jacket for Richard Aldington's *Roads to Glory*, 1930.
Published by Chatto & Windus, printed at Curwen Press. Paul Nash had
previously illustrated Aldington's *Death of a Hero* and asked that the cover of
this book of war stories should be as 'dramatic as possible'."

Both Paul and John Nash saw active service in the Artists' Rifles and served
as official war artists during the First World War, resulting in some of the
most powerful and truthful images of warfare.

Design
Paul Nash and John Nash

Despite their closeness and the fact that, to a large degree, their careers followed similar paths, Paul and John Nash were very much individuals and disliked being lumped together as 'the Nash brothers', or 'the brothers Nash'. Paul, born 11 May 1889, was nearly four years older than John, born 11 April 1893; like their younger sister, Barbara, they were all born at the oddly named Ghuznee Lodge in Earl's Court, a gloomy, respectable, West London residential area dominated by blocks of red brick mansion flats. Paul was later to describe their birthplace as 'a pariah of a house', with an outlandish name and a pretentious conservatory where nothing would grow. The latter comment being particularly significant given the fact that both he and John were to become landscape painters of distinction, and that John was to excel as one of the twentieth-century's outstanding botanical draughtsmen. Plants, whether naturalistic or as elements of dream and 'fantasy', were also to play an important part in Paul's repertoire and imagery. William Nash, their father, was a moderately successful barrister and Recorder for Abingdon, but, to the detriment of his practice, he sold the London house in 1901 and moved his family to the country in the hope that the change would benefit his ailing wife Caroline. The move was only marginally beneficial; she died in a nursing home nine years later.

However, from the point of view of the two brothers, the move got them out of the city, which they disliked, into the

Buckinghamshire countryside near Iver Heath, where the
Nashes had had roots for many generations as yeoman farmers.
The gently rolling domestic landscape of the home counties,
with its fields, hedges and trees, became an important part of
their visual vocabulary. Paul was already twelve years old at the
time of the move and was at St Paul's School; his studies there
being interrupted by a spell at a crammer in preparation for a
projected career in the Navy. This was abandoned due to his
total inability to pass the obligatory mathematics examination
and he returned to St Paul's. In the absence of any other plans
for a means of earning a living, his interest in drawing asserted
itself and, in the autumn of 1908, he went to Bolt Court, a
London County Council school, which trained commercial
artists and illustrators. Here his work attracted the attention
of both Selwyn Image and William Rothenstein, who came to
the school periodically to appraise students' work. Encouraged
by Rothenstein he then went to the Slade School, London
University, which, despite the fact that it was enjoying a golden
period under Professor Tonks, and fellow students included
Stanley Spencer, Mark Gertler, C R W Nevinson, and others, it
failed to inspire him and he left at the end of 1911.

John, who was that much younger, was educated locally in
Buckinghamshire before spending two years at Wellington
College, a military school, which was followed by a six month,
unpaid, spell as a cub-reporter on the *Middlesex & Buckinghamshire
Advertiser*. Whilst working for the paper he started making
Thurberesque caricatures plus a few naturalistic drawings,
one of which, a view of flooded meadows under a night sky,
convinced Paul that his younger brother, too, should become an
artist. However, his own disillusionment with the Slade made
him insistent that his brother should remain uncontaminated
by formal training.

Although they had not yet met, Paul had developed an epistolary
friendship with the writer and playwright Gordon Bottomley,

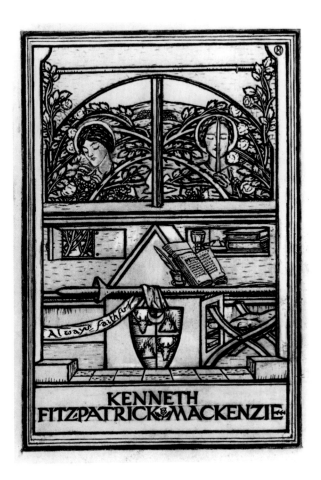

Paul Nash, design for a bookplate c.1907-10, ink and pencil. Traditional bookplate formats and the influence of the Pre-Raphaelites and Burne-Jones's illustrations for William Morris are obvious in Nash's early bookplate designs. In a letter dated 1908 he wrote to a fellow artist and bookplate collector, 'Could you tell me of any other designers with whom I could exchange notes? I am only a beginner at the art, and you are the first artist who has held out his hand'.

regularly sending him parcels of drawings for criticism. The friendship had come about through the kindness of a neighbour at Iver Heath, who had lent Paul a copy of Bottomley's *The Crier by Night*. Without thinking, Paul began to decorate the book, also pasting in an elaborate pen and ink drawing, heightened with Chinese white, depicting a Rossetti-like girl averting her face from the terrifying apparition approaching through the door.[1] The neighbour, Mrs Goldsworthy, whilst grumbling at the grubby state of the book when she got it back, was sufficiently impressed with the drawings to send it to Bottomley, thus inaugurating a long correspondence and one of the most fruitful and lasting friendships of Nash's life. The correspondence, which covers the years from 1910 to Nash's death in 1946, was published in 1955,[2] and gives a vivid account of their day-to-day activities. In May 1912 Paul sent him a packet of John's drawings. Bottomley appreciated these and responded, noting perceptively that they not only had a good sense of decorative composition but that John's blacks had a 'beautiful quality, and his pen-touch is crisp and clear and delicate.' He also commented on John's faculty for keeping his material untroubled, in which, as Bottomley said, 'he has the advantage of you.'[3] This probably referred to Paul's habit at the time of scratching out and reworking his drawings, thus giving them a 'troubled' surface, although he may also have had in mind the often overwrought quality of some of his Pre-Raphaelite inspired drawings, particularly the bookplates he had been making for friends and neighbours, in an effort to pay his own fees at the Slade and not be a burden on his father's already overtaxed resources.

About the time he quit the Slade Paul was introduced to Sir William Richmond. With his love of mysticism, he was impressed both by Richmond's patriarchal appearance and childhood connection with William Blake. The older man reciprocated by taking a serious interest in his artistic development, urging him to 'go in for Nature'. Plant-

forms, albeit more inspired by Burne-Jones's *Briar Rose* than by Nature, were already playing an important rôle in the decorative designs he was making, but now, with Richmond's encouragement, he began to turn more and more to the natural world. However, as Anthony Bertram remarks 'Richmond only pressed the trigger.'[4] During the autumn of 1911, Claughton Pellew-Harvey - normally known simply as Claughton Pellew - a fellow Slade student, who was to have a considerable influence on both the brothers, stayed with the Nashes at Iver, and enthused about the landscape. Paul was puzzled at first and acknowledged that he could not understand Pellew's devotional approach 'to a haystack'! 'Such objects, and indeed, the whole organic life of the countryside were still, for me, only the properties and scenes of my "visions". Slowly, however, the individual beauty of certain things, trees particularly, began to dawn upon me.'[5] Having opened Paul's eyes to the wonders of the local landscape, Pellew took John on holiday to Norfolk, and introduced him to the beauties of East Anglia.

Under the influence of Richmond and Claughton Pellew, Paul began to produce wash drawings such as *Landscape with a Large Tree*[6] and *The Three*[7] and by 1913 made the first of his many haunting depictions of Wittenham Clumps, a compact group of trees on the Sinodun hills near Wallingford in Berkshire, with which he had been familiar for much of his life as the family had relations living nearby. Wittenham Clumps became the most persistently emotive 'Place', recurring again and again throughout his life in paintings and drawings. One of the Clumps' earliest appearances in Nash's work was on the poster, drawn by the two brothers, for their joint exhibition at the Dorien Leigh Gallery in South Kensington in 1913. The exhibition was well received and attracted buyers including Michael Sadler[8] and Charles Rutherston, William Rothenstein's elder brother, who purchased a watercolour, *Elm Trees, Wood Lane*.[9] It was at this time that the brothers first met Edward (Eddie) Marsh, Churchill's private secretary, and Roger Fry,

who, though not a buyer, was an appreciative visitor to the exhibition, which he followed up with an invitation to Paul to design for the Omega Workshops.

The Rothensteins as a family played a constructive rôle in the brothers' lives over many years. William, from his initial meeting with Paul at Bolt Court, not only gave him encouragement, but purchased *The Falling Stars*[10] from his first exhibition at the Carfax Gallery in November 1912, and twelve years later took the innovative step of making him an assistant in the Design School at the Royal College of Art, where he was Principal from 1920 to 1935. He did the same for John ten years later. His younger sibling, Albert, gave Paul his earliest insights into the workings of a theatrical workshop in 1913, and, post-war, persuaded him to join him teaching at an art school in Oxford. Both events were significant. Stimulated by his experience assisting Rutherston with his pre-war designs for Bernard Shaw's *Androcles and the Lion*, Paul designed the costumes, sets and accessories for J M Barrie's *The Truth about the Russian Dancers*, a mime, opera and ballet produced in 1920 by Gerald Du Maurier, with music by Arnold Bax and choreography by Karsavina. The following year he made designs for Bottomley's *King Lear's Wife* and *Gruach*, as well as for Herman Ould's *Black Virgin*, but these were never realised on the stage. However, inspired by his friendship with, and admiration for the work of, Gordon Craig, he made model sets, which were exhibited at the Amsterdam Exhibition of Theatre Art and Craft in January 1922 and in June that year at the Victoria and Albert Museum. The exhibition, with further designs by Nash, then travelled to the United States. His friendship with Claud and Grace Lovat Fraser, whom he met at Dymchurch in 1920, along with Athene Seyler and the Thorndykes, also helped foster his enthusiasm for the theatre. The illustrations he did in 1924 for the Player's Shakespeare edition of *A Midsommer Night's Dreame*, edited by Rutherston, were directly influenced by this experience of designing for the stage, as were those for *The Tragedie of King Lear*.

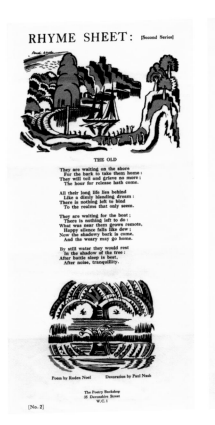

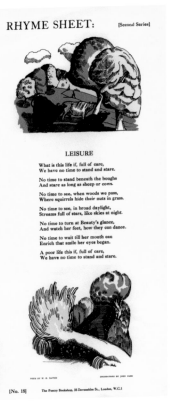

Paul Nash *The Old* by Roden Noel, 1919, and John Nash *Leisure* by WH Davies, 1920, colour letterpress. *Rhyme Sheets* for Harold Monro, owner of The Poetry Bookshop. Monro published a series of *Broadsides* and *New Broadsides*, each combining short poems and illustrations by contemporary artists with the aim of making poetry accessible to a wide audience.

A LECTURE
ON
MISSIONS IN PALESTINE, AND
EASTERN CUSTOMS,
WILL BE GIVEN (D.V.) BY
NASER ODEH
(OF JERUSALEM),
WHO WILL APPEAR IN AN ORIENTAL COSTUME, AT THE
WIDCOMBE PAROCHIAL SCHOOLS,
On Tuesday Evening, December 18th, 1877,
AT SEVEN O'CLOCK.

'I am what the servants call "flummuxed"... I have met the woman
I am going to marry.' Paul Nash wrote to Gordon Bottomley
in 1913. She was Margaret Theodosia – (also known by Paul
as Bunty, Mouse and Dove), a suffragette and daughter of the
Reverend Naser Odeh. She was born in Jerusalem where the Rev.
Odeh was chaplain to the Anglican Bishop and later educated
in Cheltenham and from 1905 at St Hilda's College, Oxford. Her
parents joined her in Oxford where Naser Odeh became a private
tutor who taught T E Lawrence Arabic.

In both cases he made model stage-sets to help him with his designs.

Claud Lovat Fraser died in 1921 at the tragically early age of thirty-two, but his influence on Nash lived on, and Nash, in his turn, enthused a number of his students at the RCA, including Edward Bawden, Eric Ravilious and Enid Marx, with an appreciation for early chapbook illustration in general and Lovat Fraser's work in particular. Harold Monro, whose Poetry Bookshop produced some of the most innovative illustrated material of the immediate post-war years, adopted the chapbook format and credited Lovat Fraser with having inspired the idea for the illustrated Rhyme Sheets, which he published, and for which Paul illustrated Roden Noel's *The Old* and Ezra Pound's *An Immorality*, whilst John produced illustrations for W H Davies's *Leisure*, Alexander Pope's *A Certain Lady at Court* and *To a Butterfly* by William Allingham. The years separating the Great War from the Wall Street Crash were to witness the heyday of the illustrated book as well as the revival of wood engraving; the Nash brothers played a crucial part in both these activities.

The 1913 exhibition at the Dorien Leigh Gallery had established Paul and John firmly on the ladder of their respective careers as artists, though their work at the time was still restricted to drawings and watercolours. The declaration of war the following year, however, inevitably affected their lives dramatically. It brought forward Paul's marriage to Margaret (Bunty) Odeh, daughter of the chaplain to the Anglican Bishop of Jerusalem, and, possibly, delayed John's to Christine Kuhlenthal, a former Slade student. Both brothers joined up, serving in France and Belgium, before, finally, becoming official war artists. Their first-hand experiences of fighting at Ypres and Oppy Wood were commemorated by outstanding works, many of which are now in the Imperial War Museum. Wittenham Clumps, and the verdant pastures

of Buckinghamshire, being replaced by bleak and sodden landscapes, whose few outstanding features consisted of the vestigial trunks of shattered trees and crumbling walls, charred and blackened by continuous fighting backwards and forwards across the no-man's-land of the Western Front. They both emerged with their reputations much enhanced.

Important as the Nashes' works are as official war artists, this book is concerned with them as designers rather than as painters; John's design work was basically confined to wood engraving and book illustration, whilst Paul, who excelled in both these fields, ranged wider, encompassing theatre design as well as designs for posters, textiles, glass and ceramics, all of which he practised by example and through his writings. He enjoyed airing his views through the columns of such publications as *The Listener, Architectural Review, Theatre Arts Monthly* and *New Witness*. He also wrote two books, *Room and Book* (1932) and *Outline*, the beginnings of an autobiography, published posthumously in 1949 with a jacket design by John in emulation of his brother – the most difficult dust-wrapper design he ever undertook. The first chapter of *Room and Book*, is entitled 'The Modern Aesthetic', and to achieve this, Paul declared, it was necessary to develop a new perception of beauty that in the course of time would inevitably establish a new style.

Both Paul and John were one hundred per cent professional painters, but, whilst John was happy to master wood engraving and add book illustration to his commercial skills, Paul's approach was more that of a perfectionist dilettante: his wish was to know how to do things rather than actively pursue their practice. Lance Sieveking, who first met him in the early months of the War, noted that 'He had a quick and amazingly *orderly* mind, and it was necessary to him to find out and grasp every detail connected with anything he undertook right at the outset.'[11] His career as a theatre designer lasted barely two years,

and, to Bottomley's regret, he destroyed all his models. Wood engraving, which formed the basis for much of his theoretical as well practical design skills, lasted through the twenties. At the beginning of the decade, when Rutherston first invited him to teach at the Cornmarket School,[12] he wrote to Bottomley: 'Albert and I are visiting pedagogues - distinguished artists from London - and in fortnightly parts - I am to ground the pupils in wood engraving. Rather an excitement don't you think? and capable of much development.'[13] Seven years later, writing in the first issue of *The Woodcut*, he described wood engraving as the most autobiographical of the crafts, but warned of the 'dangerous seduction of skilfulness.' He went on to say that it was because of his fear of such a 'danger invading the art I practise [that] I have become lately more interested in woodcut patterns than in woodcut pictures.'[14] Woodcut patterns, formal rather than representational, even when some, such as 'Cherry Orchard' and 'Romney Marsh' were initially based on the visible world, enabled him to explore abstract ideas, alongside, but separate from, his painting, which remained firmly rooted in his love of nature. The freedom to experiment with non-figurative form was important to him, and he regarded his design work as being every bit as serious as his painting.

Given the relatively small number of designs in any given medium, it is this tension between the formalistic, pedagogic Nash, and the landscape painter capable of investing places such as Wittenham Clumps, Avebury, and Kimmeridge Folly with a mystic aura, that gives them their enduring qualities. These small woodcut designs enabled him to experiment with repeat patterns, which, in turn, became suitable for endpapers, fabrics and the pattern papers he designed for the Curwen Press. At the end of a letter telling Bottomley about his textile designs he said 'the alarming envelope is from a device engraved on wood and repeated.'[15] Presumably one of his earliest trials of the repeat pattern. This was an area in which his brother John, who was equally adept as a wood engraver, had no interest, being

perfectly content to carry on depicting the natural world.

One aspect of the brothers' work that had changed dramatically during the final months of the Great War was the fact that, with their respective commissions from the Ministry of Information, they had launched into oils, adding an extra weight and authority to the images they created.

The War had had a profound effect on Paul. As Anthony Bertram says: 'Most of the other war artists only saw an explosion; but the explosion took place inside Nash.'[16] The suppressed anger and frustration that he had vented in his finest wartime paintings such as *We are making a New World*[17] may have subsided with the coming of peace, but it left him with a restlessness and a desire to help fashion the post-war world. His awareness of contemporary continental art movements, especially his involvement with the surrealists, made him a modernist, but his love of nature made him a traditionalist. In painting terms this allowed him, for the remainder of his life, to swing from relatively straightforward depictions of the English landscape and still lives, such as *Sea Holly*,[18] which won him a $300 prize at the Carnegie International Exhibition in 1929, through complex images such as *Dead Spring*,[19] to the dream sequence of the *Landscape of the Megaliths*[20] and his great aerial visions of the Second War, without compromising the integrity of his vision. John, however, despite having witnessed his full share of horrors, and producing two minor masterpieces in *Over the Top* and *Oppy Wood*,[21] was able to return to the lush cornfields of the home counties almost unscathed; one of those who had only seen the explosion.

If in his paintings and watercolours, Paul was able to extend the English landscape tradition whilst, at the same time, embracing modernism, there is no doubt that as a polemicist and designer his commitment was wholeheartedly to the machine age. *Au fond*, though, part of him still hankered after the handwork of

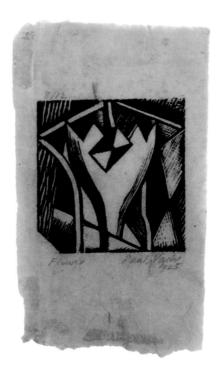

Paul Nash *Flower*, wood engraving, 1925. Editioned as a print,
Flower was transferred to lithography as a Curwen pattern paper. It
was used for the cover of *Welchman's Hose* by Robert Graves and
A Specimen Book of Pattern Papers, 1928, with an introduction by
Paul Nash, both published by The Fleuron.

the Arts and Crafts movement. It is interesting that in *Room and Book* he should link modern architecture and interior design with the Adam period, which he regarded as being 'evidence of style itself'. *Room and Book* consists of a series of essays in which he outlined his theories and ideas concerning the science of taste and the philosophy of art - in other words 'style'. Its publication coincided roughly with the realisation of his most important, completely integrated and stylish room-setting: Tilly Losch's bathroom, commissioned by her husband, Edward James. Although now only known from photographs, it was a symphony in glass of one kind and another - purple, pink and black, plain, patterned, semi-opaque and mirrored - with sanitary fittings in black glazed earthenware and a table, towel rail and the dancer's exercise ladder constructed from chromium-plated tubing. In *Room and Book* he championed glass, steel and wood as the most important materials for modern interior furnishing. He also fully appreciated that pattern need not only be two- or three-dimensional, but could also be reflective; a potential he exploited to its full in Tilly Losch's bathroom, in which the multiple reflected images of the dancer's own figure were intended to be the principal ingredient of an ever-changing balletic mural.

On a more mundane level, he exploited the reflective possibilities of glass in the designs he made at this time for decorative sheet glass for Chance Brothers, and the crystal drinking glasses and decanters he designed for Stuart and Sons. His one big excursion into wood was the mural he created for the exhibition at Charing Cross Station in 1936 promoting the Timber Development Association. In contrast to his enjoyment of the sparkle of light on glass, he detested highly varnished woods almost as much as he detested marquetry pictures, so he designed a non-figurative, geometric mural utilising panels of unstained veneers. In doing this he was entirely reliant on the differing textures and colours of the woods, ranging from blue-grey to the rich reds of chestnut, to make a visual impact

on the transient audience who passed through the exhibition as they hurried to or from their trains. His biggest public statement at this time, however, was the formation of the much heralded, but short-lived Unit One group, in 1933. This brought together eleven like-minded people from different disciplines; the group consisted of two architects: Wells Coates and Colin Lucas, two sculptors: Henry Moore and Barbara Hepworth, and seven painters: Wadsworth, Nicholson, Burra, John Armstrong, John Bigge, Frances Hodgkins and himself. They held one exhibition, in April 1934, at the Mayor Gallery in London, which subsequently toured to the Midlands, Wales and Northern Ireland. A book of the same title, edited by Herbert Read, was published simultaneously, containing statements of their individual beliefs as well as photographs of their studios, hands and examples of their work.

Ambitious as some of these schemes were, it was probably in the field of wood engraving, book designing and illustration - painting apart - that Paul was most consistently happy, and it was here that he shared most closely his interests and enthusiasms with his brother John. It was in order to study to become an illustrator that Paul had gone to Bolt Court as a teenager and, if taking the bookplates that he designed at that time as the beginning, and *Aerial Flowers*, which he wrote and designed shortly before his death on 11 July 1946, as a finale, illustration was the one art form he practised continuously throughout his working life. The processes, of course, varied considerably over the years from line block, to wood engraving, lithography and photography. With the exception of photography, the same is true of John's illustrational work. Both brothers produced their first drawings for publication in the immediate aftermath of the First War; Paul's to illustrate John Drinkwater's *Loyalties*, produced by the Beaumont Press in 1918, and John's for Lance Sieveking's *Dressing Gowns and Glue* the following year. Bottomley had said in his first response to the sight of his drawings, back in 1912, how impressed he and

his wife, Emily, had been by John's 'profound belief that the human countenance fundamentally resembles a bird's'.[22] This quality of John's humorous drawings is a notable characteristic of his illustrations to *Dressing Gowns and Glue*, as well as to Sieveking's later book of nonsense rhymes, *Bats in the Belfry*, and *The Nouveau Poor; A Romance of Real Life in London after the Late War* by Belinda Blinders - a pseudonym for Desmond Coke. Sieveking, a writer and broadcaster, and Paul had met whilst serving in the Artists' Rifles in the early months of the War, and both brothers were to do designs for him; Paul's dust-jacket in black, white and terracotta for *Smite and Spare Not*, with its dramatically angled lettering, is one of the best he did, and aesthetically is on a par with the green and orange tooled leather binding he devised for the Gregynog Press's *Shaw Gives Himself Away*.

The brothers collaborated on *The Sun Calendar for 1920*, produced by the Sun Engraving Co., which had a cover by Paul and title page by Rupert Lee. Each month was represented by an appropriate line drawing or wood engraving - six each by John and Paul - accompanied by poems ranging from Herrick and Blake to Edward Thomas and Edith Sitwell. William Heinemann's and the Nonesuch Press, respectively, produced *Places* (1923) and *Genesis* (1924), two of Paul's finest books of wood engravings, whilst Frederick Etchells and Hugh Macdonald published John's *tour de force* in the medium, *Poisonous Plants: Deadly, Dangerous and Suspect* in 1927. However, John's little *Catalogue of Alpine and Herbaceous Plants*, issued the previous year in a limited edition of a hundred copies, with its hand-coloured line illustrations, must rank as one of the most delectable of his published works. Issued by Clarence Elliott of the Six Hills Nursery at Stevenage, it is modest in scale, but formed the basis of a lifelong friendship between these two keen plantsmen, who also shared a passion for fishing. *Genesis*, with its emphasis on abstract subjects such as The Face of the Waters, The Stars Also and Contemplation, gave Paul scope to explore pattern and, daringly, in the initial illustration, The Void to produce a completely

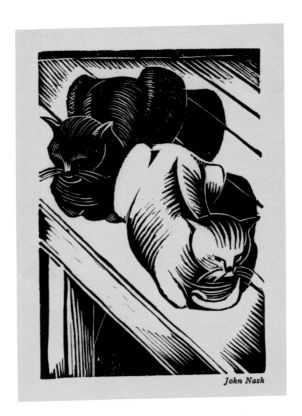

One of John Nash's first wood engravings, c1919, illustrating the anonymous poem *On the Uncertainty of this Life* for *The Sun Calendar for the Year 1920*, arranged by Paul Nash, with illustrations by Paul and John Nash and Rupert Lee. Published by the Sun Engraving Company Ltd.

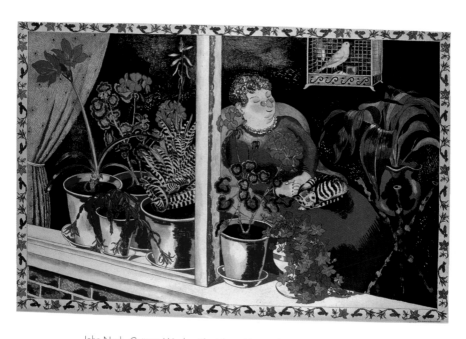

John Nash, *Cottage Window Plants*, auto-lithograph, 1946, published by
School Prints as part of their series of inexpensive poster prints for schools.

blank, black image incorporating the opening verse: *IN THE BEGINNING GOD CRE-/ ATED THE HEAVEN AND THE / EARTH + AND THE EARTH WAS / WITHOUT FORM AND VOID*, with type set in Neuland, the first time it had been used in England. By the end of the decade both brothers had largely abandoned wood engraving for other mediums - mainly either line drawing or lithography, and, in Paul's case, photography also. Paul's greatest excursion into illustration was the production of the thirty-two illustrations to Sir Thomas Browne's twin texts *Urne Buriall and The Garden of Cyrus*, published by Cassell's. The process for this was exacting; for each plate Nash made initial designs in colour, from which he then made black chalk artwork; from these the collotype 'key prints were produced, which were then hand-stencilled in watercolour by the highly-skilled girls at the Curwen Press, to complete the final illustrations. Herbert Read described *Urne Buriall* as 'one of the loveliest achievements of contemporary English art.'[23] John's essays in lithography were seldom totally happy, with the exception of *Cottage Window Plants*, one of the most delightful of the prints for schools series produced in 1946.

The Second World War found the two brothers in very different circumstances, although both were commissioned initially as official war artists. John was restless, feeling that he had already said everything he had to say about war as a result of the previous conflict, and transferred to the Royal Marines, serving as a Staff Officer at Rosyth, where he was visited by Eric Ravilious, and later at Portsmouth. Paul, meanwhile, was attached to the Air Ministry, but due to the chronic asthma that dogged his last years, was forbidden to fly, except in his imagination. Somehow, despite increasing debilitation, he still managed to summon the energy to create his final masterpieces, *The Battle of Britain*;[24] *Totes Meer*[25] and *The Battle of Germany*.[26] He died on 11th July 1946.

John outlived him by thirty-one years, continuing to delight an ever-growing band of admirers with his plant drawings

and watercolours of the English countryside, often painted on holidays with fellow Academicians Edward Bawden and Carel Weight, though the holidays he probably enjoyed most were with his fishing and gardening friends Clarence Elliott and Robert Gathorne-Hardy. He had already illustrated Gathorne-Hardy's *Wild Flowers in Britain* and, in the next few years, illustrated two further books by him: *The Tranquil Gardener* and *The Native Gardener*, as well as an anthology of Suffolk verse, *Parnassian Molehill*, edited by his elder brother, the Earl of Cranbrook. In all, during the post-war years, he illustrated a further twenty books, including a new edition of Gilbert White's *Natural History of Selborne* and the witty *Happy New Lear*. However, it was primarily as a landscape painter that he was regarded by the public. He had been elected an Associate of the Royal Academy early in the War, and in 1951 was made a full Academician; the accolade of a retrospective exhibition at Burlington House in 1967[27] was a tribute to his long and distinguished career during which he had enriched the pastoral tradition for which England had been justly famous for the previous two hundred years.

Paul, however, was more than a distinguished landscape painter, he was undoubtedly one of the most significant and innovative English artists of the twentieth century. As a painter he produced masterpieces in each of the four decades of his working life, and, at the same time, his influence on twentieth-century British design far exceeded his actual output in any specific field. He followed his own precepts advocated in *Room and Book*; namely the study of surface and grain, texture and vibration. He also felt with his eyes, seeking out harmony of form and colour, 'searching, not for old styles, but for the principles of our past that we may create a new thing.'[28] It was this ability to perceive the essence of whatever he undertook that made his designs so absolutely right and why, sixty years after his death, they still look so fresh.

Peyton Skipwith

Picture references are to the catalogue raisonné by Andrew Causey, *Paul Nash*, Clarendon Press, 1980

1. *The Crier by Night*, Causey 8, Collection Carlisle Public Library
2. *Poet and Painter: Being the Correspondence Between Gordon Bottomley and Paul Nash, 1910-1946*, edited by Claude Colleer Abbott and Anthony Bertram, Oxford University Press, 1955
3. *Ibid*, Letter 39, 7 July 1912
4. Anthony Bertram, *Paul Nash: The Portrait of an Artist*, Faber & Faber, 1955, p.68
5. quoted Bertram, op. cit. p.68
6. Causey, No.43
7. Causey, Nos.51 & 58
8. Sir Michael Sadler was a noted collector and Vice-Chancellor of Leeds University. In 1920 he launched a scheme to decorate Leeds Town Hall with murals. Both the Nashes, Stanley Spencer, Albert Rutherston, Edward Wadsworth and the Leeds artist, Jacob Kramer, produced designs, but the scheme was never carried through.
9. Causey, No.81, Collection Manchester City Art Gallery, Rutherston Collection
10. Causey, No.38
11. Lance Sieveking, *The Eye of the Beholder*, Hulton Press, 1957, p.49
12. The Oxford School of Painting & Drawing, which amalgamated with the Ruskin School in 1922
13. *Poet and Painter*, op. cit. Letter 130, c. end July,1920
14. *The Woodcut: An Annual*, No.1, 1927, pp. 30-38
15. *Poet and Painter*, op. cit. Letter 1931 January 1927
16. Bertram op.cit. p.99
17. Causey, No.227, Collection Imperial War Museum, London
18. Causey, No.575
19. Causey, No.634
20. Causey, No.786
21. Both Collection Imperial War Museum, London
22. *Poet and Painter*, op.cit. letter 37, 7 July 1912
23. Herbert Read, *Philosophy of Modern Art*, Faber & Faber, 1952, p.180
24. Causey, No.1060, Collection Imperial War Museum, London
25. Causey, No.1064, Collection Tate Britain, London
26. Causey, No.1172, Collection Imperial War Museum, London
27. The Dictionary of National Biography states inaccurately that he was the first living artist to be so honoured. This accolade was bestowed on Sir Frank Brangwyn in 1953
28. Paul Nash, *Room and Book*, Soncino Press,1932, p.28

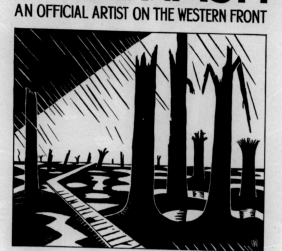

Exhibition poster, 1918, incorporating Nash's *Void of War* lithograph, with type added by the printer. His *Void* and *We are making a New World* paintings, closely related to *Void of War* were included in the exhibition.

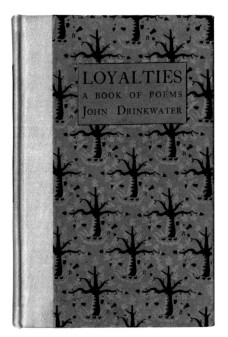
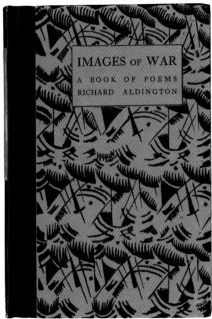

Loyalties, 1918, and *Images of War*, 1919. Poems by John Drinkwater and Richard Aldington, published by the Beaumont Press. Both books were hand printed and published in hand-coloured and uncoloured limited editions. Nash's illustration for Drinkwater's *Moonrise*, (*Where are you going you pretty riders?*) bears similarities to Blaue Reiter paintings and for Aldington's dramatic verses he produced abstract details from his war paintings that reflect Vorticist and Suprematist images.

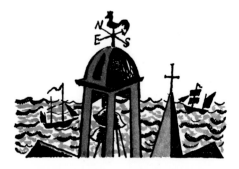

Southampton Bells

Perspective

Blackbird

Illustrations from *Loyalties*, John Drinkwater

Moonrise

Crocuses to EC

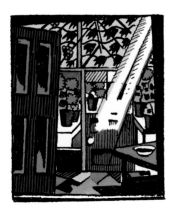

History

Proem (May 1917)

In the Trenches

A Ruined House

Illustrations from *Images of War*, by Richard Aldington

Trench Idyll

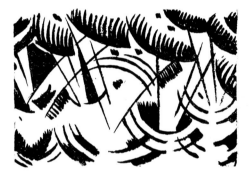

Barrage

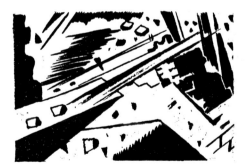

Bombardment

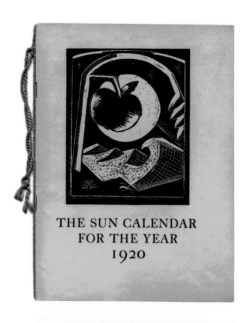

The Nightingale, Sacheverall Sitwell

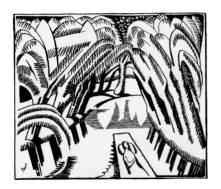

The King of China's daughter, Edith Sitwell

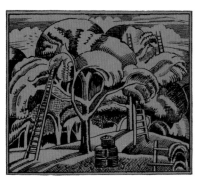

Moonlit Apples, John Drinkwater

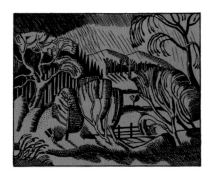

Roots and leaves themselves alone, Walt Whitman

Separation, Walter Savage Landor

The Sun Calendar for the year 1920, a booklet of poems, illustrated by Paul Nash, John Nash and Rupert Lee (a fellow student of Paul Nash at the Slade), with poems by Walt Whitman, Edith Sitwell and John Drinkwater, selected by Paul Nash. Front cover '*Device*' wood engraving and calendar pages illustrated with line drawings.

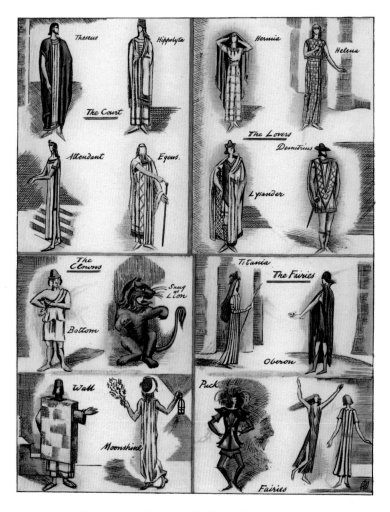

A Midsommer Night's Dreame, The Player's Shakespeare.
Published by Ernest Benn, 1924, printed by the Shakespeare Head
Press, *Costumes for some of the characters*, line drawings and
watercolour, reproduced by the collotype process.

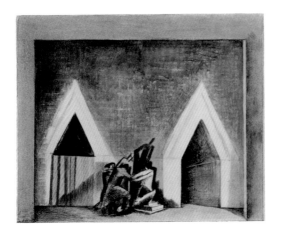

Act III Scene 7, Gloster is attacked by Cornwall and Regan

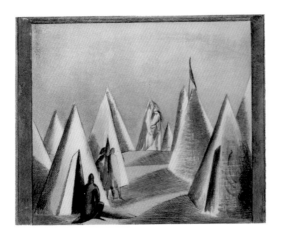

Act V Scene 3, Lear enters the British camp with Cordelia dead in his arms

The Tragedie of King Lear, The Player's Shakespeare. Published by Ernest Benn, 1927, printed by the Shakespeare Head Press. Collotype from pen and watercolour drawings.

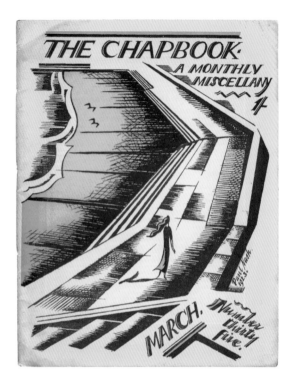

The Chapbook, 1923, Nash illustrates the sea wall at Dymchurch, the subject of several of his best known paintings and wood engravings.

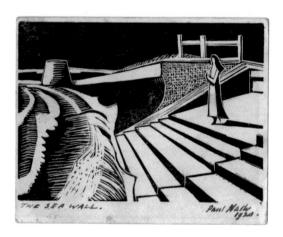

Wood engraved illustrations for *Mr Bosphorus and the Muses, a short history of poetry in Britain*, a surreal play-poem in four acts, by Ford Madox Ford, published by Duckworth and Co, 1923

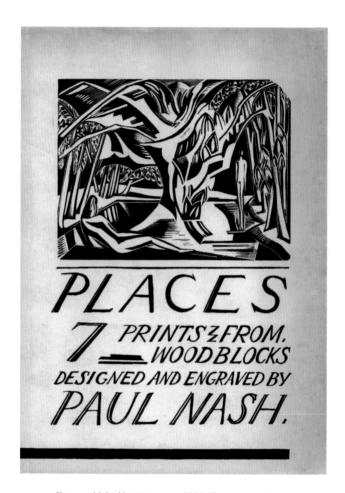

Places, published by Heinemann, 1923. The seven wood engravings and 'illustrations in prose' convey Nash's feelings for his 'spirit of place'. The cover engraving *Meeting Place*. *Buntingford* was the home of his close friend, the artist, Claud Lovat Fraser's parents.

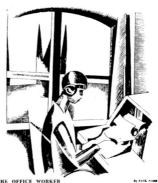

THE OFFICE WORKER By PAUL NASH

THE HOUSEWORKER

Cover illustrations in black and white
for *The Labour Woman*, 'a monthly
journal for working women', 1924-26,
from 'The Advertiser and the Modern
Artist' in *Commercial Art* magazine,
May 1931.

THE MACHINIST By PAUL NASH

IN THE BEGINNING GOD CRE-
ATED THE HEAVEN AND THE
EARTH + AND THE EARTH WAS
WITHOUT FORM AND VOID

Genesis, published by Nonesuch Press, 1924, was Paul Nash's first book printed at the Curwen Press, through the introduction of Francis Meynell. The twelve engravings illustrate the first book of the Bible, set in Rudolph Koch's *Neuland*, the first use of the type in England. Above, *Void* illustrated full size.

Creation of the Firmament

Vegetation

Man and Woman

Contemplation

Double Crown Club

The third dinner of the Double Crown Club at the Holborn Rest-aurant on Tuesday February 17th at 7.30 p.m.

Chairman Albert Rutherston
Guest William Rothenstein
Subject Book Illustration
Designer Paul Nash

MENU .

Huîtres Natives ou Hors D'Œuvres Variés
Petite Marmite Crème Madrilene
Filet de Barbue Bonne-femme
Poulet Poëlé Belle-meuniere
Feuilles de Laitues Vinaigrette
Bombe Plombiere
Gaufrettes
Café

Wood engraving for the third dinner of the Double Crown Club, 1925. Although the illustration has been described as a folded table napkin, Nash entitled it *Abstract Design*.

Repeat pattern binding and wood engraving for *Wagner's Music Drama of the Ring*, by L Archier Leroy, published by Noel Douglas, 1925. Nash devised the book's four illustrations as stage sets.

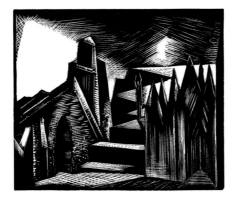

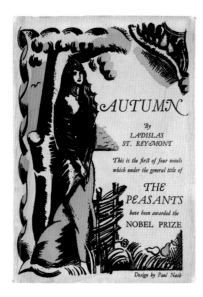
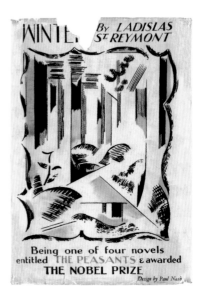
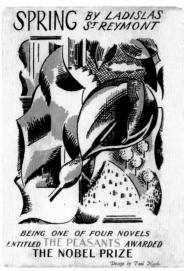
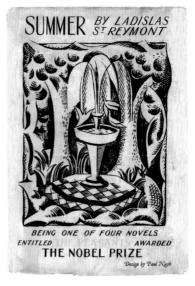

The Peasants by Ladislas St Reymont published by Jarrolds, 1925-1926. Nash obviously had a change of design direction after the first book, *Autumn*. For the later books the illustrations are more translucent and incorporate hand drawn lettering.

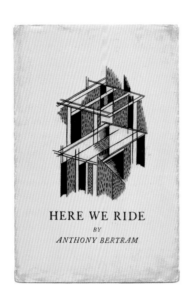
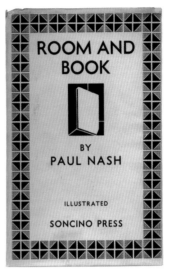

Nash uses transparent planes for the jacket of *Here We Ride*. Published by George Allen and Unwin, 1927. The author Anthony Bertram also wrote the commentary for the monograph *Paul Nash* published by Ernest Benn in 1923, which illustrates Nash's paintings, costume designs and stage sets. He later wrote Nash's biography published by Faber and Faber, 1955. *Room and Book*, 1932, is typeset in Curwen sans serif with an abstracted 'book in room' wood engraving. The 'unit' border was designed by Nash for use at Curwen.

Cherry Orchard, 1931 (left), block printed crêpe de Chine in three colourways, for Cresta Silks and *Fugue*, 1936 (right), screen-printed linen by the Old Bleach Linen Company (right). *Cherry Orchard*, based on the design for *Wild Cherry*, 1920, originated in Nash's illustrations for his *Images of War* drawings.

Alperton, wool moquette upholstery for London Transport. 1930s.

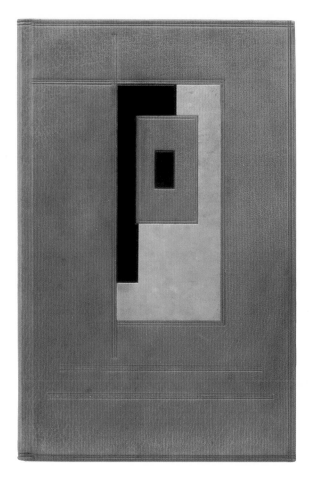

A Song About Tsar Ivan Vasilyevitch, by Mikhail Lermontov, translated by John Cournos. Published by the Aquila press, 1929. Nash designed the text layouts, and wood engravings in black and red and binding in red morocco inlaid with black and ivory niger.

Nash's pattern papers for the Curwen Press have been in
constant use since their first printings, 1925-1928.

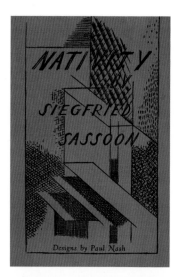

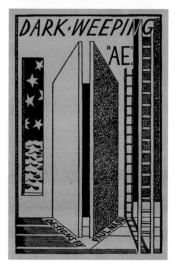

Nativity, by Siegfried Sassoon, Faber and Gwyer, 1927 and *Dark Weeping* by AE (George Russell), Faber and Faber, 1929. Ariel Poems numbers 7 and 19, printed by Curwen. The ladder on the cover of *Dark Weeping* makes a three dimensional appearance in Tilly Losch's bathroom.

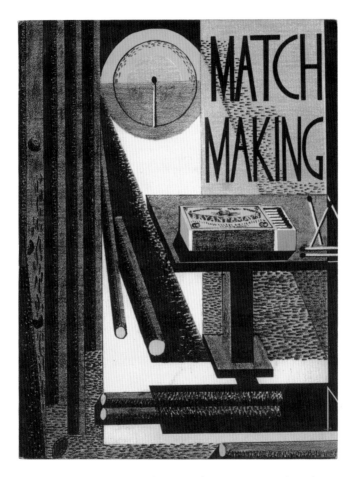

Lithographed cover for a history of match manufacturing at Bryant and May, by
EP Leigh-Bennett with photographs by Francis Bruguière, 1931. The cover image,
without Nash's hand lettering is repeated in reverse on the back cover.

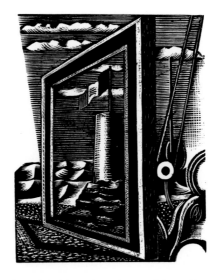

A frequently used Nash frame device for Samuel Courtauld's wood-engraved bookplate, c1930

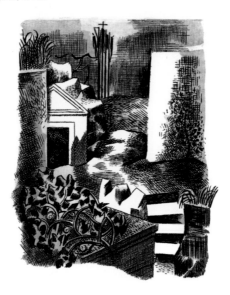

The Widow of Ephesus, watercolour stencilled illustration for *Saint Hercules and Other Stories*, by Martin Armstrong, printed at Curwen, 1927.

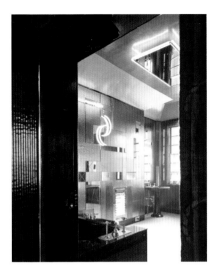

Now dismantled, the glass-walled bathroom in coloured and mirrored glass, 1932, was commissioned by Edward James for his wife the dancer Tilly Losch

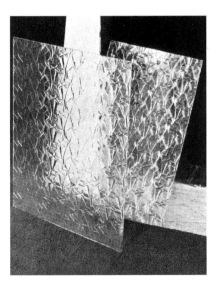

Illustrated in *Design for Today*, in July 1933, Nash designed *Coptic* rolled sheet glass for Chance Brothers in 1931.

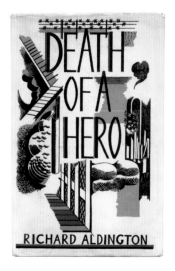

Chatto and Windus, 1929

Heinemann, 1935

Putnam, 1932

Jarrolds, 1926

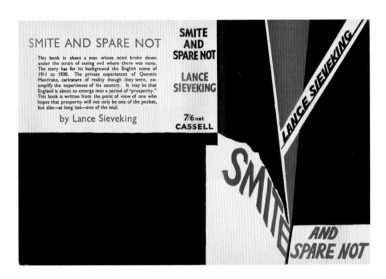

Unusually for the time Nash wrapped his design around the covers. Cassell, 1933

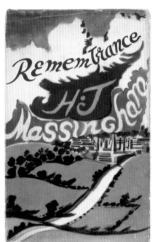

Cassell, 1936 Batsford, 1941

Sir Thomas Browne's *Urne Buriall and The Garden of Cyrus*,
edited by John Carter, published by Cassell and Company, 1932.
The thirty-two collotype key drawings were printed at Charles
Whittingham and Griggs and the text and watercolour stencils
at Curwen Press. The binding, designed by Nash is in brown
morocco and vellum with vellum inlays and gilt tooling. Nash,
who frequently complained to his publishers and printers, was
justifiably pleased with the book, but publication coincided with
the depression and at 15 guineas the book failed to sell well.
Twenty years later Herbert Read described it as 'one of the
loveliest achievements of contemporary English art'.

Mansions of the Dead

Ghosts

Vegetable Creation

Sorrow

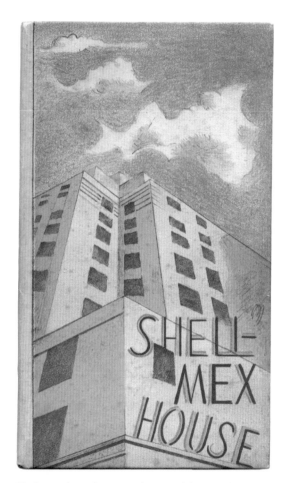

'The history of a modern metropolis is in its skyline' says the
introduction to the small-format guide to Shell-Mex House, printed
at Curwen, 1933. For the lithographed cover from a coloured
crayon and watercolour drawing, Nash illustrates the dramatic
perspective of the building, built on the site of the old Hotel Cecil.
His 'flint-clouds' echo many of his 1930s paintings.

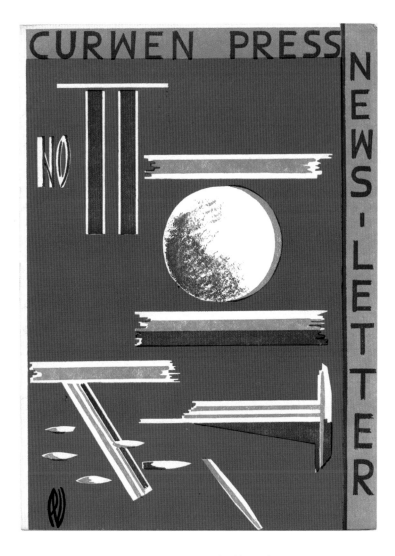

Curwen Press Newsletter No 11, three-colour lithograph, 1935. Curwen produced sixteen numbers between 1932 and 1939, many with covers by contemporary artists, including Graham Sutherland, John Piper, Eric Ravilious, Edward Bawden and John Nash. Nash's design is closely related to his *Voyages of the Moon* and other mid-thirties paintings.

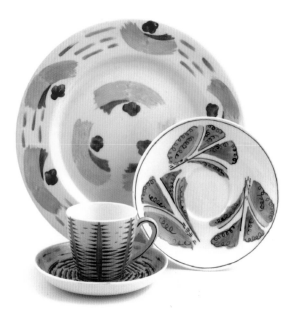

Nest and *Forest* for Foley China, large plate for Clarice Cliff's Bizarre Pottery, and sherry glasses and decanter for Stuart Crystal. The idea of employing artists to create designs for a group of manufacturers to be exhibited in 1934, at Harrods, came from TA Fennemore of E Brain and Co the makers of Foley China.

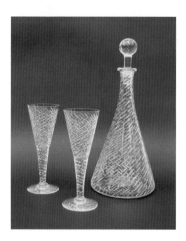

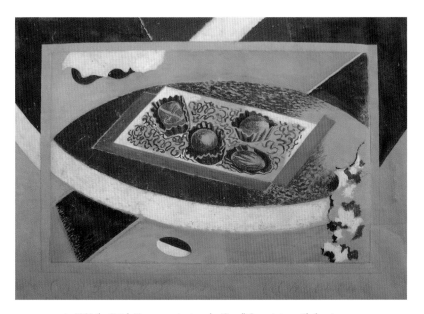

In 1931 the British Government set up the Gorell Commission with the aim of encouraging manufacturers to improve their product design. Cadbury's commissioned artists including Arthur Rackham, Laura Knight, Mark Gertler, McKnight Kauffer and Paul Nash to design chocolate boxes. Few, without 'chocolate box' illustrations, including Nash's 1936 design, got beyond the proof stage. But, through his membership of the Society of Industrial Artists, his contributions to magazines and books and his teaching, Nash was instrumental in making design a recognised profession.

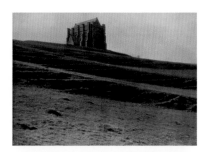

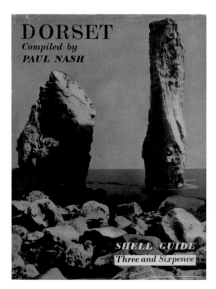

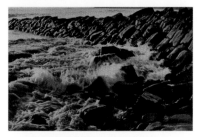

Shell Guide to *Dorset*, 1935. Nash in his introduction says he has based his Dorset guide on John Betjeman's (the general editor) 'first and best of the series guide to *Cornwall*'. In compiling the guide and practising his recently developed interest in photography Nash found locations and images that reflect his personal vision. The front cover is a surreal photomontage of the Old Harry Rocks.

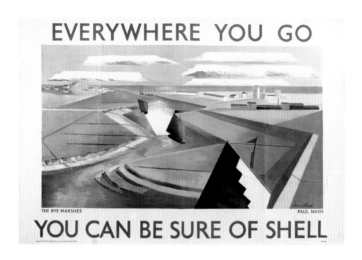

Rye Marshes, 1932 and Footballers, 1935, lorry bill posters commissioned by Jack Beddington, Shell's advertising manager, and indefatigable supporter of experimental designers.

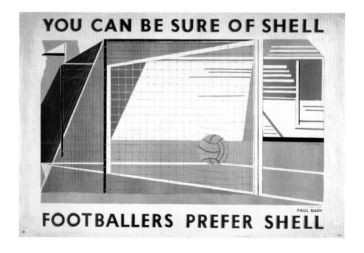

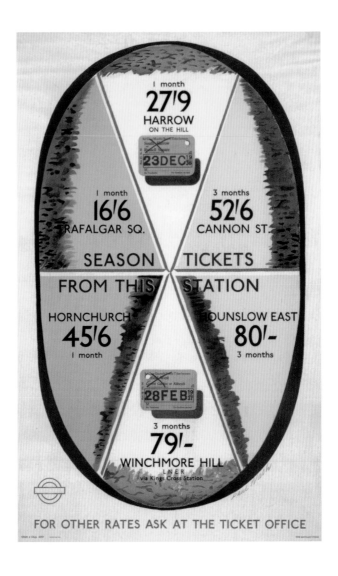

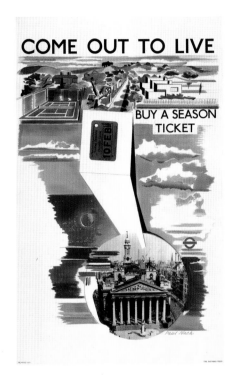
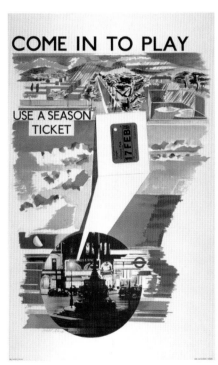

Three posters for London Transport, 1936, designed to promote the use of season tickets. *Come out to Live* and *Come in to Play* combine sun and rain illustrations and night and day photography. They were designed to be used individually or as 'pair' posters.

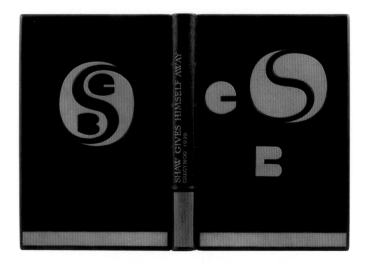

Binding incorporating George Bernard Shaw's initials, dark green morocco, inlaid with orange for *Shaw Gives Himself Away*, published by the Gregynog Press, 1939.

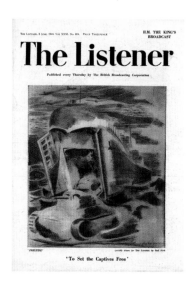

A commissioned drawing for *The Listener, Prelude*, captioned 'to set the captives free'. Nash's anthropomorphic landing craft seems to be eating tanks and reflects his surreal, wartime collages.

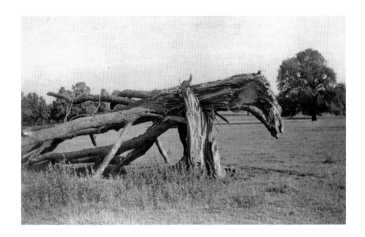

Written in 1939, *Monster Field*, a booklet reproducing the hand-written essay, photographs and watercolours, was Nash's last publication before his death in 1946. A companion booklet *Aerial Flowers*, designed by Paul Nash was not published until 1947.

Printer's 'flowers' from *Aerial Flowers*.

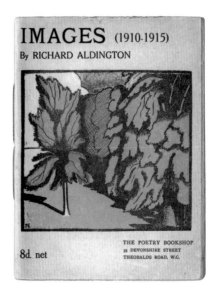

Images and *Cadences*, both published in 1915. Printed in blackline with hand-colouring for the Poetry Bookshop, they were John Nash's first cover designs.

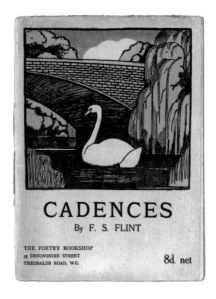

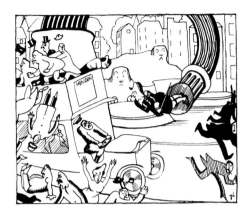

Idle Curiosity 'wither and whence and how and why' (above) and
*On Choosing a Career – Read aloud as fast as you possibly can,
without pause for breath* (below)

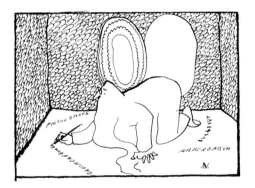

Dressing Gowns and Glue, by Captain Lance de G. Sieveking
DSC, 1919. Sieveking's nonsense poems are introduced by
G K Chesterton and Nash's comic drawings by
Max Beerbohm. The book, published by Cecil
Palmer and Hayward, edited by Paul Nash,
ran to three editions.

I consulted Dogs and Sparrows.

Candlemas Eve, Robert Herrick

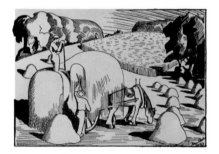

Adlestrop, Edward Thomas

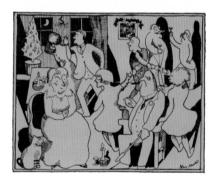

Christmas (The Pickwick Papers), Charles Dickens

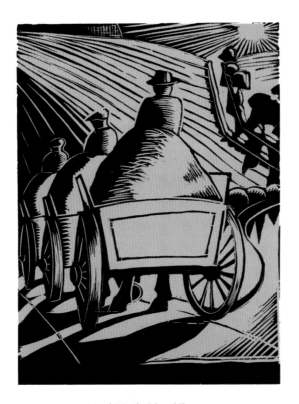

Head & Bottle, Edward Thomas

John Nash's contribution to *The Sun Calendar, 1920,* were line drawings and what he recalled as his first wood engravings. Nash, here, was happy to alternate between comic and topographical drawings as well as wood engraving.

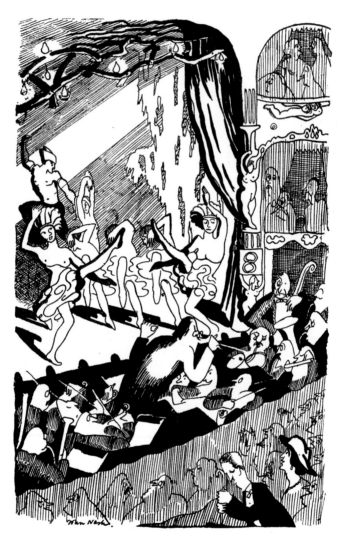

The Ballet at Cremorne, the frontispiece to *The Nouveau Poor: A Romance of Real Life in London after the Late War*, a riotous comic novel by Belinda Blinders (Desmond Coke), published by Chapman and Hall, 1921.

Nash's first book for Robert Gibbings, co-founder of the Society of Wood Engravers and director of the Golden Cockerel Press, *Directions to Servants* by Jonathan Swift, 1925, was his only, and not altogether successful, attempt at comic engraving.

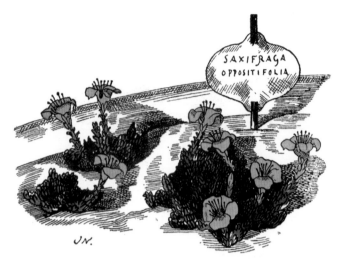

Saxifraga oppositifolia splendens

Catalogue of Alpine and Herbaceous Plants, 1926, by the nurseryman, plant collector, or as he preferred, 'gardener', Clarence Elliott, Six Hills Nursery, Stevenage.

Campanula pusilla miranda

*Saxifraga Grisebachii
Witley Variety*

Gentiana pyrenaica

From an edition of 100 hand-coloured copies. *Alpine and Herbaceous Plants* was Nash's first book exclusively devoted to plants and established his reputation.

Cyclamen neapolitanum

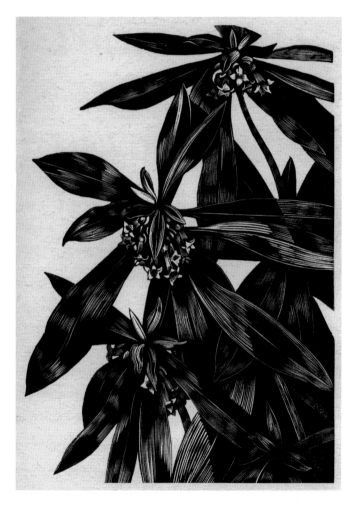

Poisonous Plants: Deadly, Dangerous and Suspect, 1927, with an
introduction by John Nash, Haslewood Editions, published by Etchells
and Macdonald. Nash's twenty full-page wood engravings are printed
in dense black on 'dead leaf' Renkers Ingres paper, bound in dull brown
silk, and green cloth spine. Printed at Curwen Press the whole book is
perfectly appropriate to the subject, the equal to his brother's *Urne Buriall.*

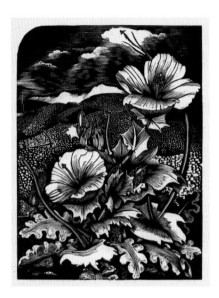

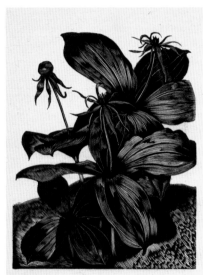

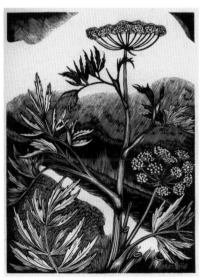

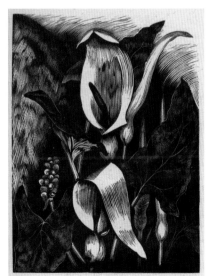

The Early Whistler by Wilfred Gibson, Number 6 of the Ariel
Poems, published by Faber and Gwyer, 1927. Colour line
illustrations printed at Curwen Press. The editor Richard de la
Mare asked contemporary poets and artists to collaborate on
the series of booklets as an alternative to Christmas cards.

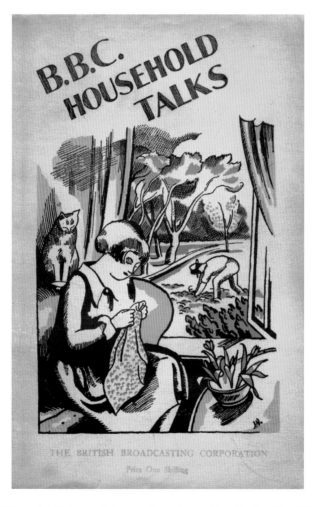

BBC Household Talks cover illustration in three colours, published by the BBC, 1929.

The Curious Gardener, by Jason Hill (Dr Anthony Hampton), published by Faber and Faber, 1932. Nash drew line drawings for this and Hill's *The Contemplative Gardener* published by Faber & Faber in 1940

Tobacco Plant, wood engraving, for an advertisement commissioned by Curwen, 1929.

Illustrations to *Maria-Fly, Missing,* and *The Nap* from *Seven Short Stories* by Walter de la Mare, published by Faber and Faber, 1931. Nash illustrated each of the seven stories and a frontispiece for an edition of 170 copies coloured by stencils on handmade paper, together with an unlimited 'trade' edition.

Men and Fields by Adrian Bell, lithographs and line drawings, printed at the Curwen Press, published by Batsford, 1939. Bell and Nash lived as neighbours on the Essex/Suffolk border, recording in words and pictures the changes in rural life before the outbreak of war.

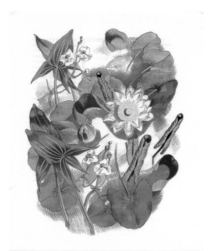

ABOVE: AUTO-LITHOGRAPH BY JOHN NASH PRINTED IN FOUR COLOURS

THE CURWEN PRESS NEWS-LETTER NO. 14

Two auto-lithographs in four colours for Curwen publications, *Newsletter No. 14*, 1937 and an advertisement for the Baynard Press in *Signature* no.12, 1939.

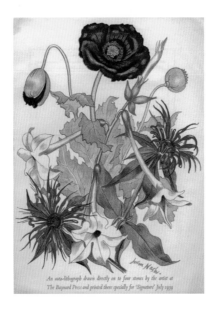

An auto-lithograph drawn directly on to four stones by the artist at The Baynard Press and printed there specially for 'Signature' July 1939

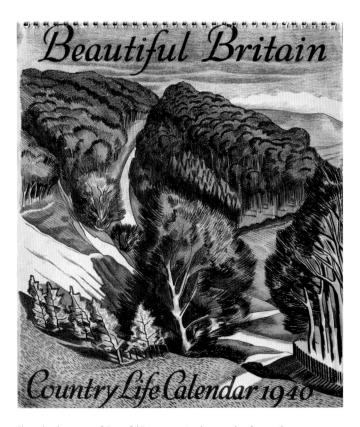

The calendar pages of *Beautiful Britain* contain photographs of tranquil country scenes, undoubtedly planned before the declaration of war. Eric Ravilious illustrated the 1939 *Country Life* calendar and John Nash provided the cover illustration a year later.

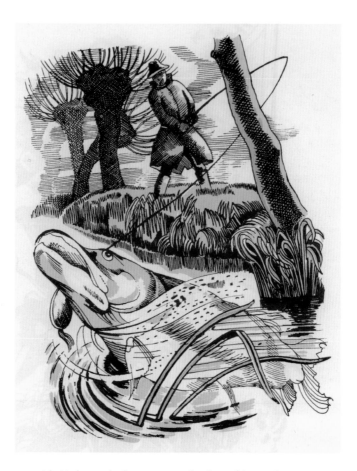

John Nash wrote that his interests were "gardening, fishing and painting, in that order". *November* calendar illustration for the Colchester printers Benhams, 1958, with a commentary by Ronald Blythe

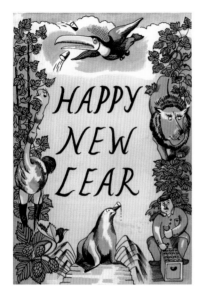

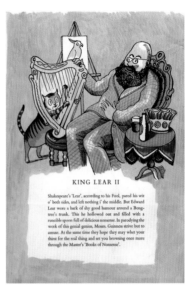

Happy New Lear, a sixteen page booklet of rhymes, puns and witty illustrations. Commissioned by advertising agency SH Benson for Guinness, 1957.

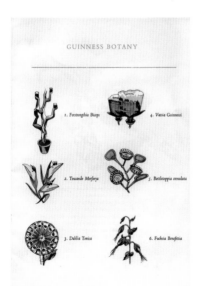

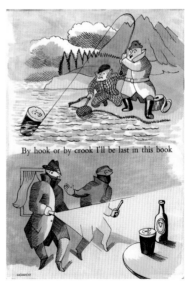

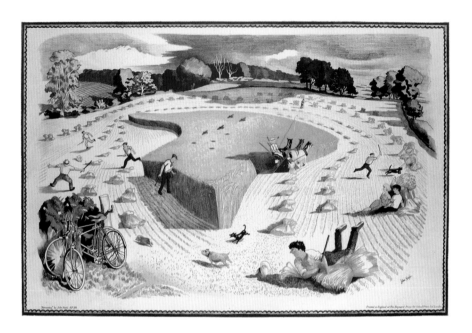

Harvesting. Auto-lithograph from the second series of School Prints, 1946-47.

Nash returned to his early comic style drawing his own Christmas cards each year from the 1940s and into the early 1970s.

'I have known a whole village up in arms' The Natural History of Selborne, 1972

Nash illustrated Gilbert White's *The Natural History of Selborne* for the
Lutterworth Press in 1951 in black and white. In 1972 it was reissued by the
Limited Editions Club with colour added to the original illustrations. The book
was designed by his friend and biographer John Lewis and printed at WS
Cowell. The Earl of Cranbrook wrote in his introduction to the new edition,
'these witty and observant drawings are worthy of Gilbert White's great and
enduring book… between 1919 and 1971 John Nash has illustrated more
than thirty books and amongst these his *Selborne* must stand supreme'.

Chronologies

Paul Nash

1889 Born in London on 11 May.

1901 Moved to Iver Heath, Buckinghamshire.

1903-6 Attended St Paul's School, London.

1906-9 Full time student at Chelsea Polytechnic and later Bolt Court Commercial Art School, Fleet Street. Encouraged by William Rothenstein to attend the Slade.

1908-10 Designed bookplates for friends.

1910-11 Attended Slade School of Fine Art.

1912 First one-man exhibition at the Carfax Gallery.

1913 Engaged to Margaret Odeh. Met Roger Fry and produced designs for the Omega Workshops. Exhibited in New English Art Club's annual exhibition, and at the Dorien Leigh Gallery with John Nash.

1914 Enlisted in Artists' Rifles as a private. Met Lance Sieveking. With John Nash and Rupert Lee painted murals for restaurant in Judd Street, Bloomsbury.

1917 Served at Ypres Salient. Invalided to London. Made official war artist following the exhibition of his Ypres Salient work, returned to France.

1918 Commissioned by Ministry of Information to paint *The Menin Road*. Shared a studio with his brother John at Chalfont St. Peter. First illustrated book, *Loyalties*, published.

1919 Made his first wood engravings. Lived in Margaret Nash's flat in Alexandra Mansions, Bloomsbury.

1921 Rented a cottage at Dymchurch. Exhibited three textiles in the Friday Club exhibition at Heal's Mansard Gallery.

1923 *Places*, *The Chapbook* and *Mr Bosphorus and the Muses* published.

1924 *Genesis* published.

1924-5 Taught in the Design School at the Royal College of Art. Students included Eric Ravilious and Edward Bawden. Visited France and Italy. Moved to Iden, Sussex.

1926 Textiles sold at Modern Textiles, Beauchamp Place.

1928 Retrospective exhibition of his wood engravings at the Redfern Gallery.

1929 Death of his father. Designed bookbinding, the *Song about Tzar Ivan Vasilyevitch*. Commission for textile designs for Cresta Silks.

1930 Founder member of the Society of Industrial Artists (now Chartered Society of Designers). Visited France. Moved to Rye. Took his first photographs.

1931 Visited USA as British representative on international jury for the Carnegie Exhibition at Pittsburgh. Gorrell Committee set up.

1932 *Urne Buriall and The Garden of Cyrus* published. Organised *Room and Book* exhibition at Zwemmer Gallery. *Room and Book* published.

1932-4 President of Society of Industrial Artists. Council members included Serge Chermayeff, Frank Dobson, Frederick Etchells and Graham Sutherland.

1933 Founded Unit One. Visited south of France.

1934 Visited Spain and North Africa. Returned to London and rented a cottage, Romney Marsh, Kent. Herbert Read's *Art and industry* published. Ceramics and glass exhibited at Harrods.

1935 Moved to Swanage where he compiled the *Dorset Shell Guide*. British

Art and Industry exhibition at the Royal Academy.

1936 Returned to London to Eldon Road, Hampstead. Participated in the International Surrealist Exhibition in London. Contributed to *Axis*, edited by Myfanwy Piper.

1937 Contributed *Surrealism and the Printed Book* to *Signature* magazine.

1939 Moved to Oxford. Designed his last bookbinding, *Shaw Gives Himself Away*.

1940 Appointed official war artist.

1941 Designed his last bookjacket for H J Massingham's autobiography, *Remembrance*.

1946 *Monster Field* published. Died on 11 July.

1947 His last illustrated book, *Aerial Flowers*, published.

John Nash

1893 Born in London on 11 April.

1901 Moved to Iver Heath, Buckinghamshire.

1908-11 Educated at Wellington College.

1912 Worked as junior reporter on *The Middlesex and Buckinghamshire Advertiser*.

1913 Joint exhibition with his brother Paul at Dorien Leigh Gallery, London.

1914 Founder member of the London Group, exhibited at their first exhibition at the Goupil Gallery.

1915 Exhibited at the first exhibition of the Camden Town Group at the Goupil Gallery.

1916 Enlisted in the Artists' Rifles.

1918 Commissioned as an official war artist. Shared a studio with Paul at Chalfont St. Peter.

1919 First book, *Dressing Gowns and Glue*, published.

1920 Founder member of the Society of Wood Engravers, *Sun Calendar* published.

1921 First one-man show at the Goupil Gallery, London. Moved to Meadle, Buckinghamshire.

1924-9 Taught at the Ruskin School of Art, Oxford.

1927 *Poisonous Plants* published.

1930 One-man show at the Goupil Gallery, London.

1934-40 Taught in the Design School of the Royal College of Art, London.

1937 *Bucks Shell Guide* published.

1938 Painting trip to Bristol with Eric Ravilious.

1939 First of several visits to the Gower Peninsula.

1940 Appointed official war artist to the Admiralty. Elected Associate of the Royal Academy.

1941 Commissioned as Captain. Visited by Eric Ravilious in Dundee.

1945 Moved to Bottengoms Farm, Wormingford, Suffolk. Rejoined the staff of the Royal College of Art, London.

1951 Elected Royal Academician. *Natural History of Selborne* published.

1954 Retrospective exhibition at the Leicester Galleries, London.

1957 First of several regular visits to the Isle of Skye.

1962 First of many painting trips to Cornwall with Edward Bawden.

1963 Awarded the CBE.

1967 Retrospective exhibition at the Royal Academy, London.

1971 *Natural History of Selborne* re-issued in colour.

1977 Died 23 September.

A good use for this book at this point.